1832-1883

Color Your Own
MANET
PAINTINGS

ÉDOUARD MANET

Rendered by
Marty Noble

D1089134

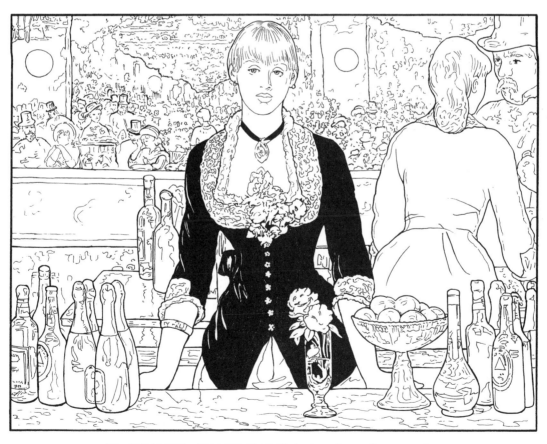

DOVER PUBLICATIONS, INC.
Mineola, New York

NOTE

French painter and printmaker Édouard Manet (1832–1883) was the son of a high-ranking government official who denounced Manet's inclination toward art. Rather than attend law school as his father urged him, the young artist began a six-year apprenticeship with painter Thomas Couture. Manet spent many hours at the Louvre copying the works of such masters as Titian and Velásquez, and embarked on several trips to museums in Germany, Italy, and the Netherlands. He rented his own studio in 1856, but his first submission to the Salon exhibition of the Académie des Beaux-Arts in 1859 was rejected, turning his gallery debut into a scandal.

Although Manet's art was strongly rooted in the classics, he was often criticized for his modernity. The Salon rejected several of his paintings due to their controversial subjects. Condemnation greeted his work Le Déjeuner sur l'herbe, which in 1863 was included in the "Salon of the Rejected," held alongside the official Salon exhibition at the command of Napoleon III. At the Universal Exhibition held in Paris in 1867, Manet showed about fifty of his paintings at a small stand outside the official enclosure. In the catalog, he said of himself, "M. Manet has tried neither to overthrow an old manner of painting nor to create a new one. He has sought only to be himself, not someone else."

Having adopted the style of painting out-of-doors, Manet became a greatly respected practitioner of Impressionism, though he did not participate in the official exhibitions of the group. While the Impressionists juxtaposed colors to suggest the play of light and to define objects, Manet is distinctive for placing a greater emphasis on drawing, in the manner of the Spanish, Flemish, and Dutch old masters. His art was a major influence on younger painters, who in turn led him to lighten his palette to better express the effects of natural light. Manet's Jeanne: Spring disarmed his fiercest critics at the Salon. His last major painting, A Bar at the Folies-Bergère, is a masterful portrayal of a young woman and endures as one of his most compelling pieces.

All thirty of the plates in this book are shown in full color on the inside front and back covers. Use this color scheme as a guide to create your own adaptation of a Manet or change the colors to see the effects of color and tone on each painting. Captions identify the title of the work, date of composition, medium employed, and the size of the original painting.

Copyright

Copyright © 2008 by Dover Publications, Inc.
All rights reserved.

Bibliographical Note

Color Your Own Manet Paintings is a new work, first published by Dover Publications, Inc., in 2008.

DOVER *Pictorial Archive* SERIES

International Standard Book Number
ISBN-13: 978-0-486-46202-8
ISBN-10: 0-486-46202-1

Manufactured in the United States of America
Dover Publications, Inc., 31 East 2nd Street, Mineola, N.Y. 11501

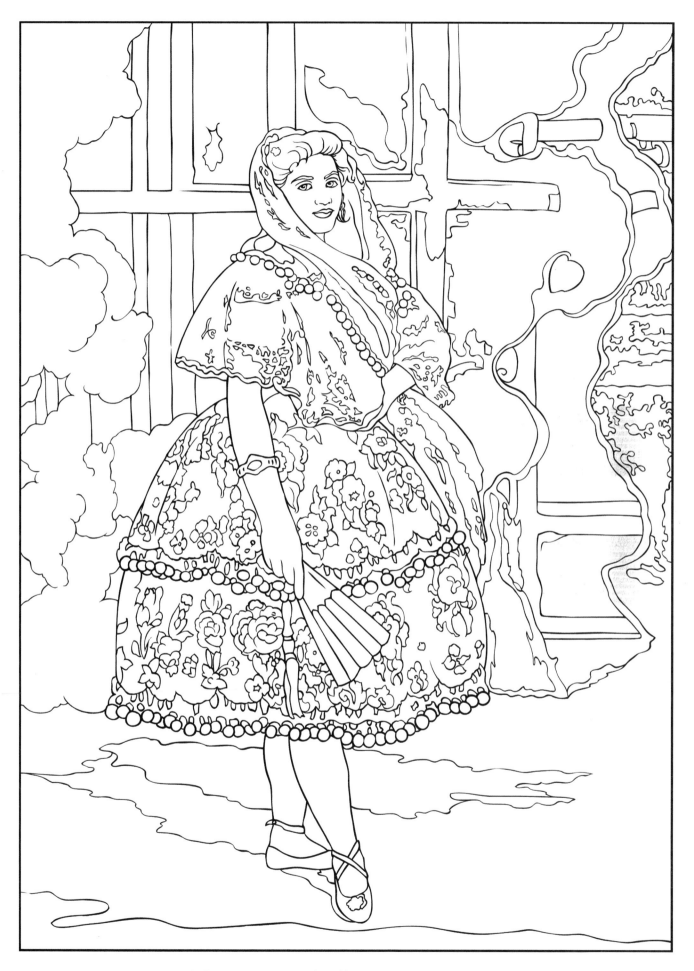

1. **Lola de Valence.** 1862. Oil on canvas. 48⅜ in. x 36¼ in.

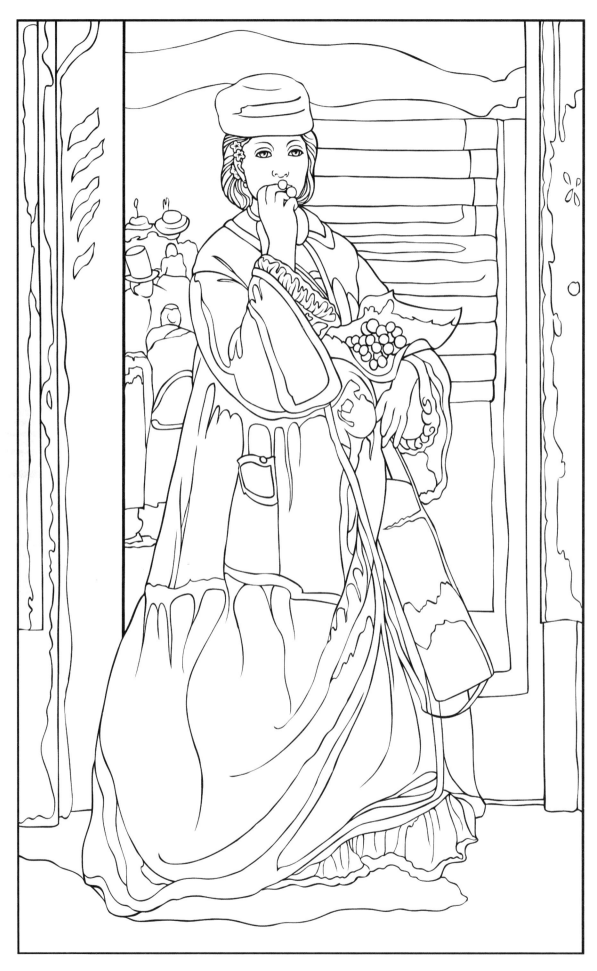

2. **The Street Singer.** c. 1862. Oil on canvas. 67⅜ in. x 41⅝ in.

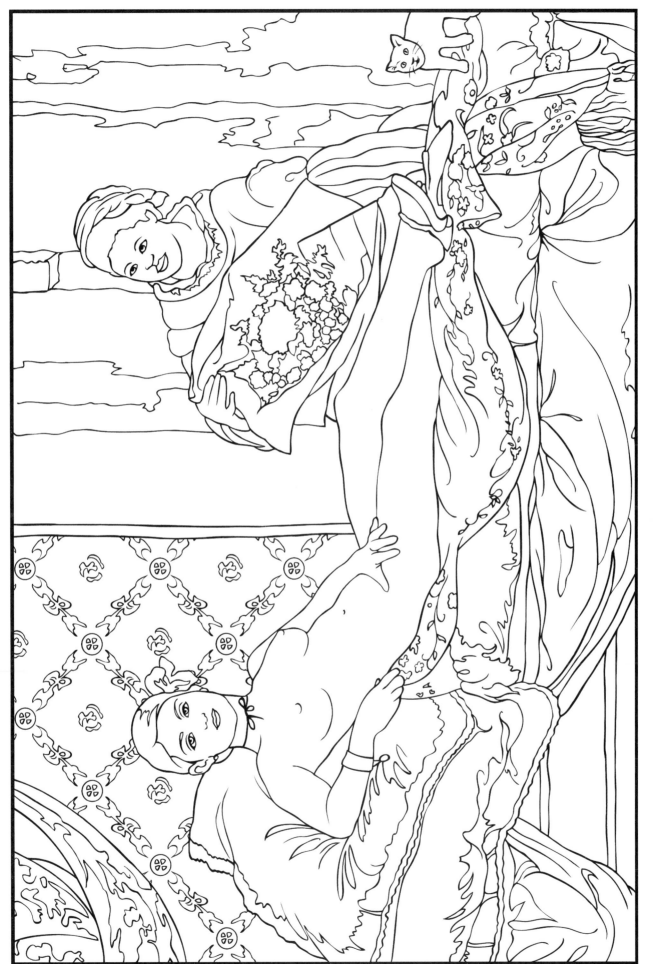

3. **Olympia.** 1863. Oil on canvas. 51¼ in. x 74¾ in.

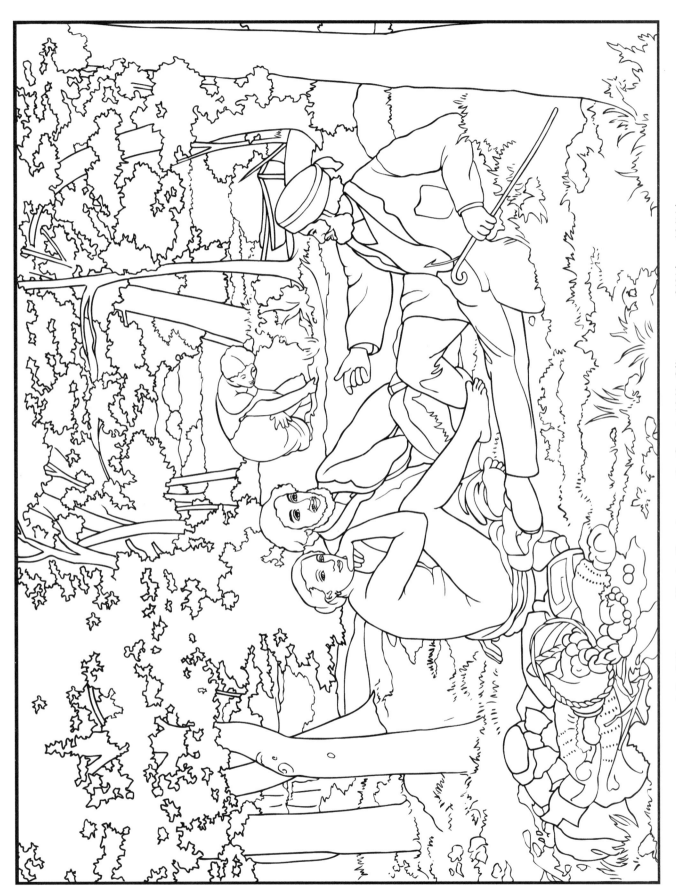

4. Le Déjeuner sur l'herbe (Luncheon on the Grass). 1863. Oil on canvas. 81⅛ in. x 104⅛ in.

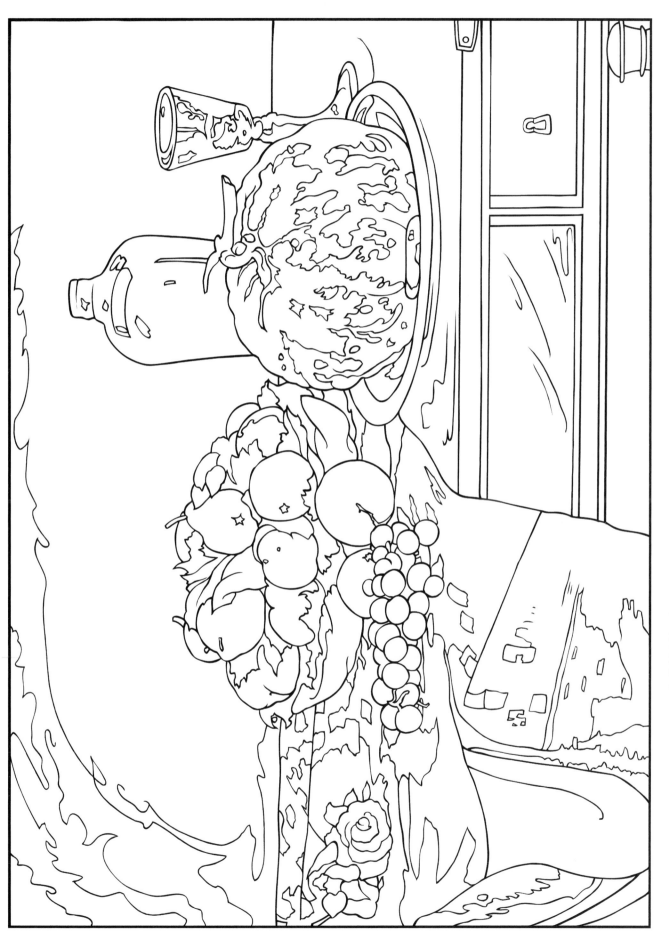

5. **Still Life with Melon and Peaches.** c. 1866. Oil on canvas. 27⅛ in. x 36¼ in.

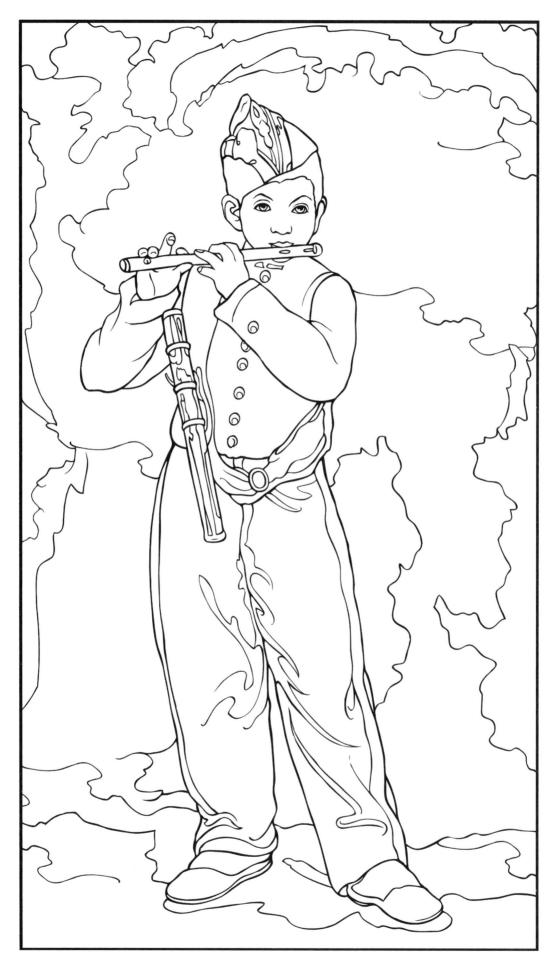

6. **The Fifer.** 1866. Oil on canvas. 64⅝ in. x 38 in.

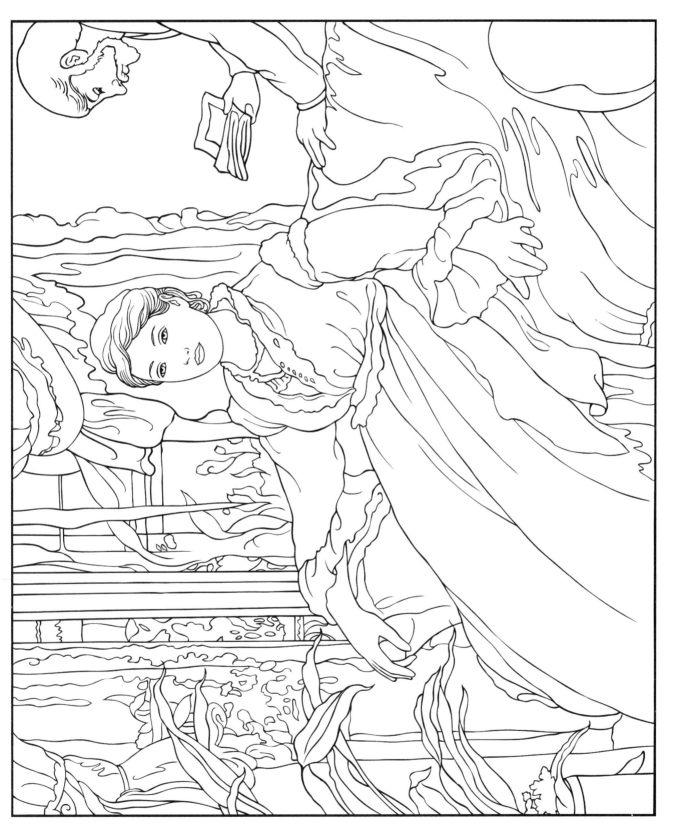

7. **Reading (Mme. Manet and Léon)**. c. 1866–75. Oil on canvas. 24 in. x 29¼ in.

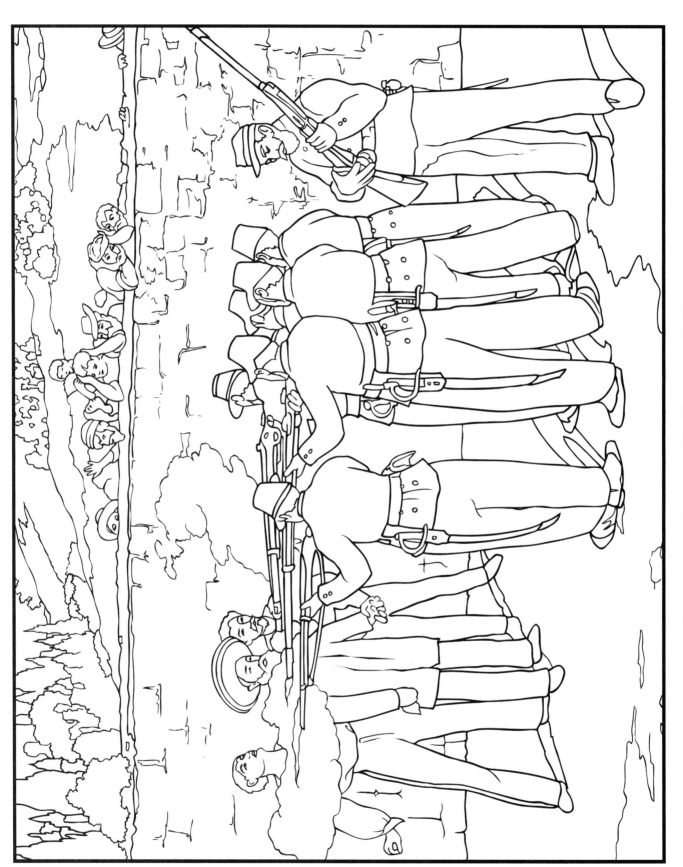

8. **The Execution of Maximilian.** 1868. Oil on canvas. 100¹³/₁₆ in. x 122 in.

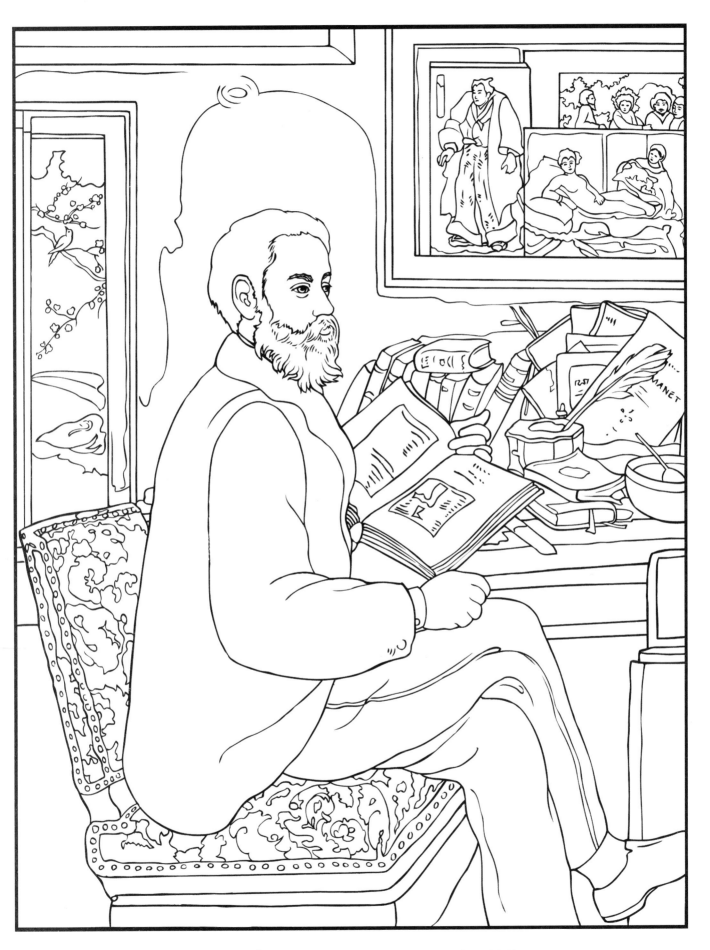

9. **Portrait of Émile Zola.** 1868. Oil on canvas. 57½ in. x 44⅞ in.

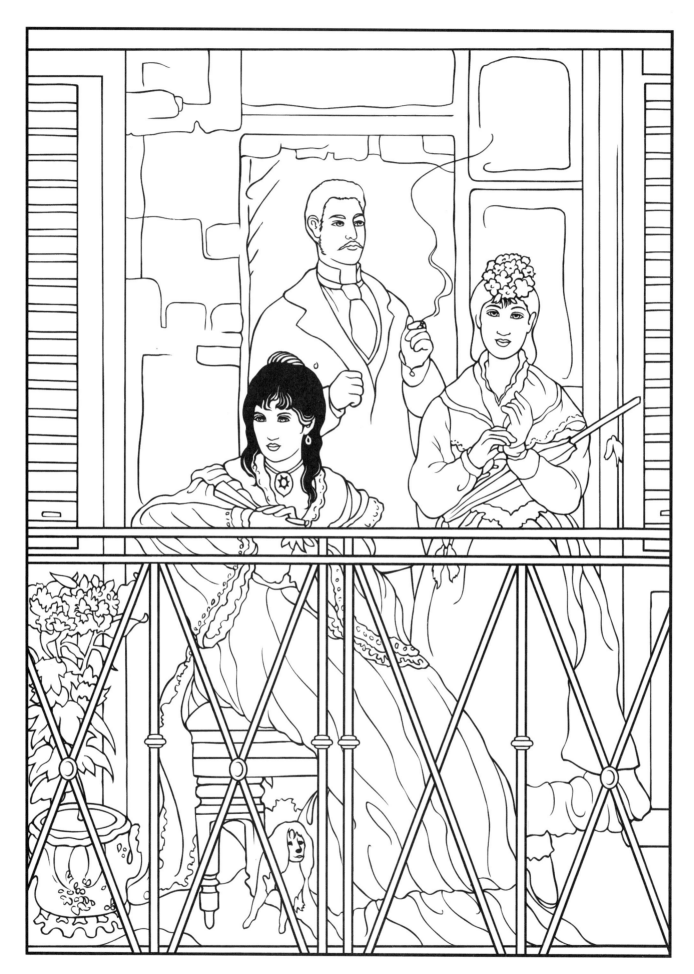

10. **The Balcony.** 1868–69. Oil on canvas. 67⅝ in. x 50 in.

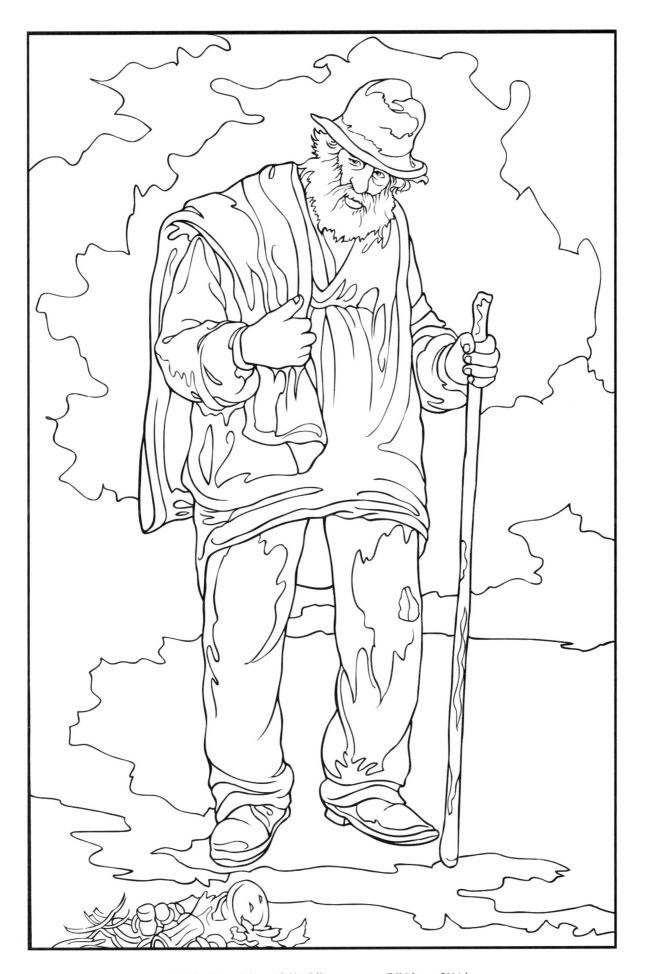

11. **The Ragpicker.** 1869. Oil on canvas. 76¾ in. x 51¼ in.

12. **Portrait of Eva Gonzalès.** c. 1870. Oil on canvas. 75¼ in. x 52⅜ in.

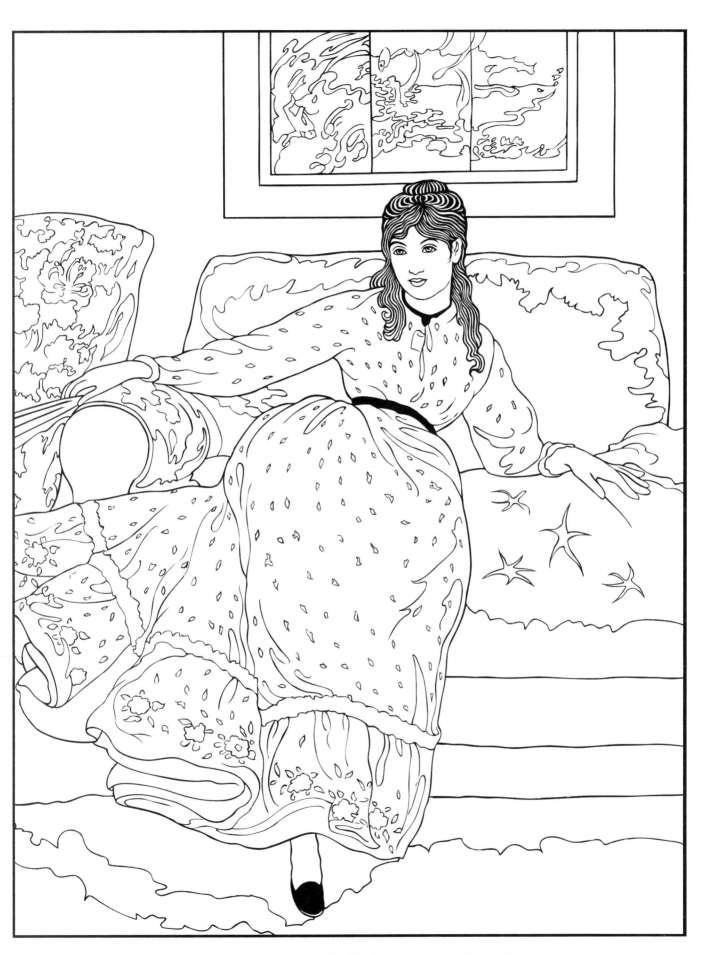

13. **Repose (Berthe Morisot).** 1870–71. Oil on canvas. 58¼ in. x 43¾ in.

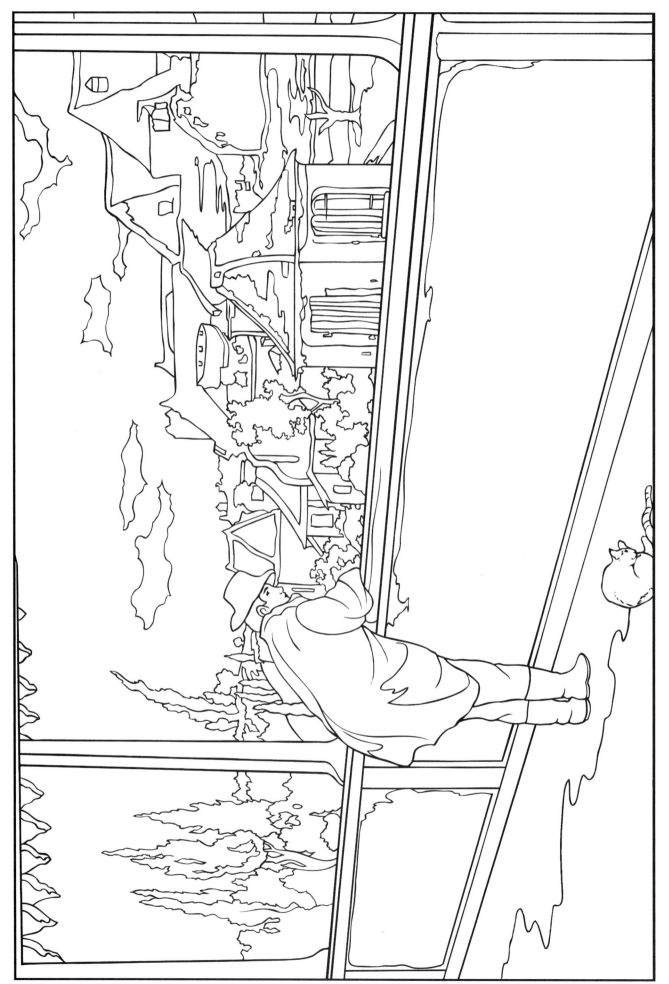

14. **Léon on the Balcony, Oloron-Sainte-Marie.** 1871. Oil on canvas. 16¾ in. x 24⅝ in.

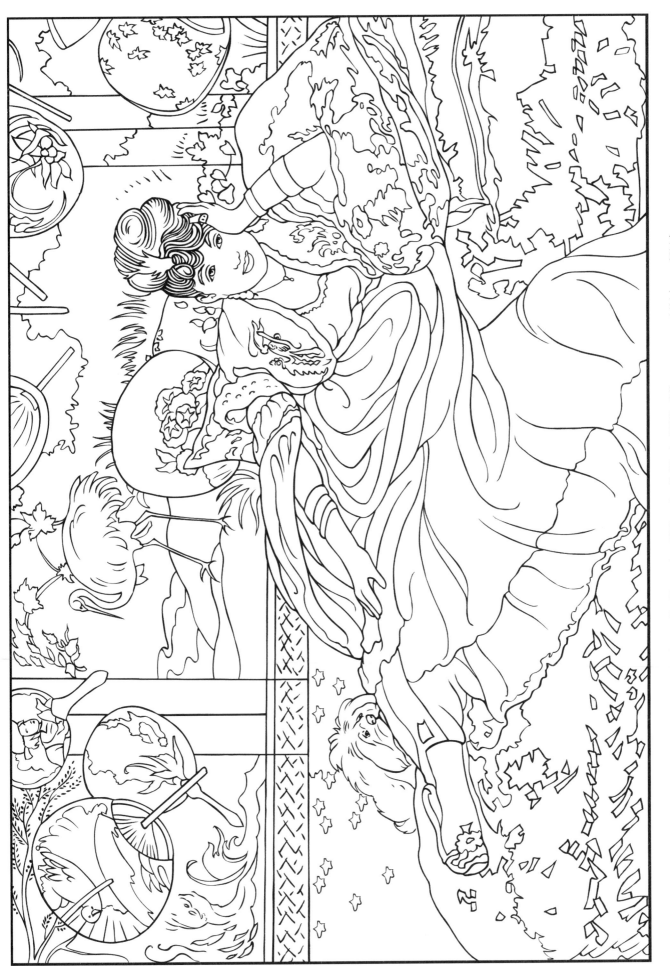

15. **La dame aux éventails (Portrait of Nina de Callias)**. 1873. Oil on canvas. 44¾ in. x 65½ in.

16. **The Railway**. 1873. Oil on canvas. 36½ in. x 45 in.

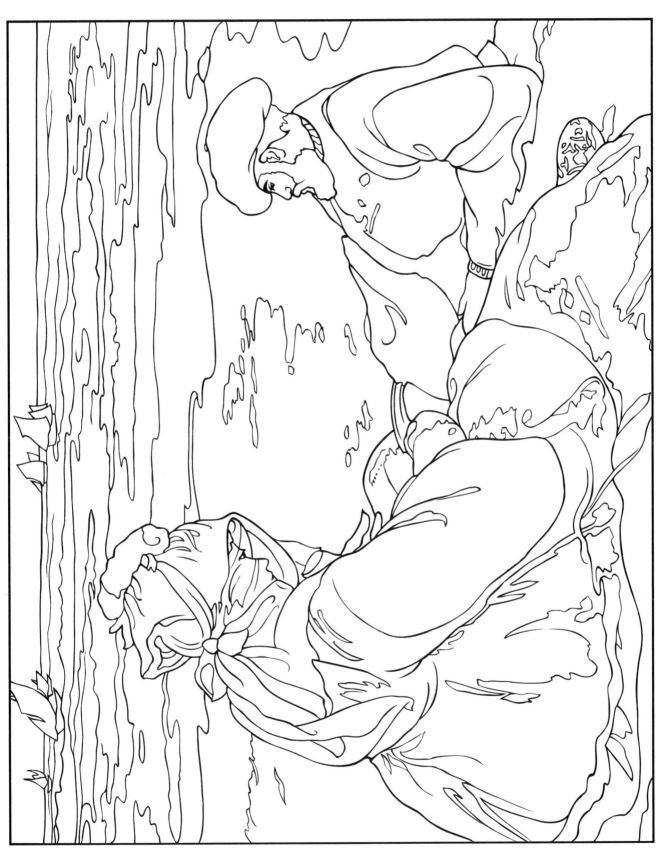

17. **Sur le plage (At the Beach).** 1873. Oil on canvas. 23½ in. x 28¾ in.

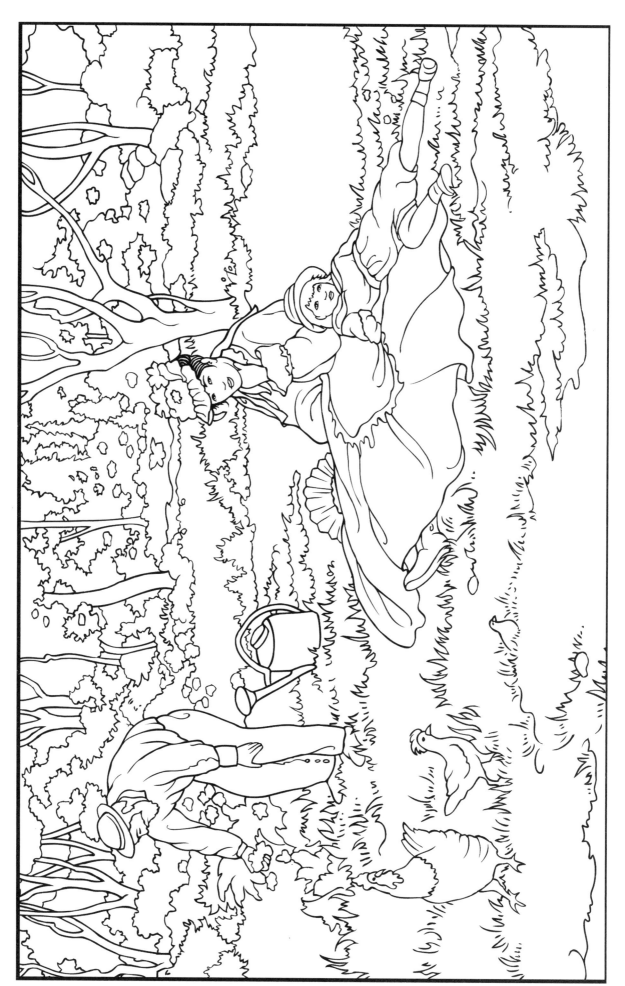

18. The Monet Family in the Garden. 1874. Oil on canvas. 24 in. x 39¼ in.

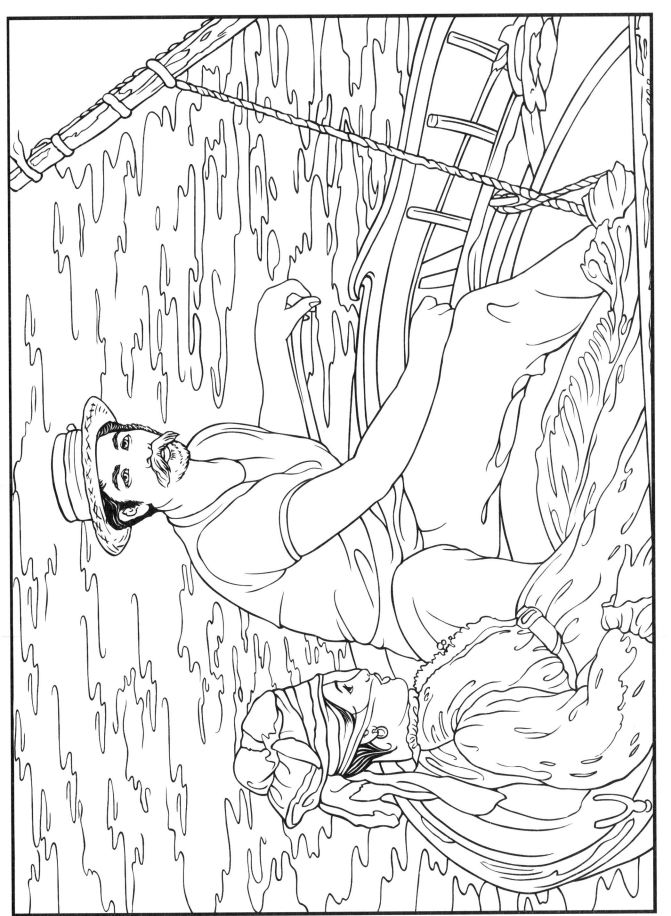

19. **Boating.** 1874. Oil on canvas. 51¼ in. x 38¼ in.

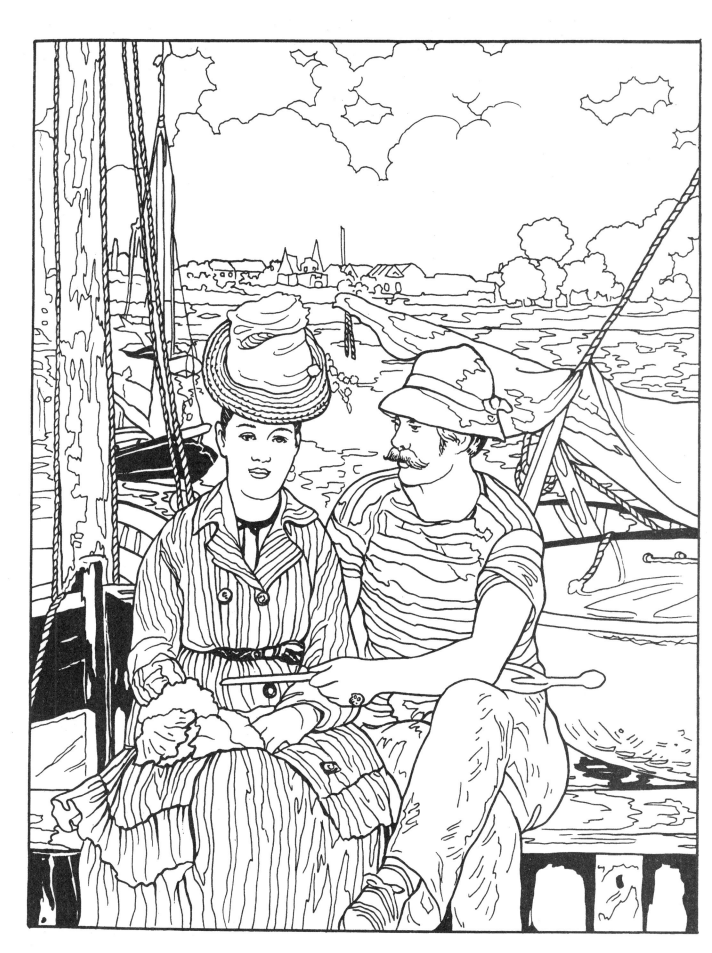

20. **Argenteuil.** 1874. Oil on canvas. 58½ in. x 45¼ in.

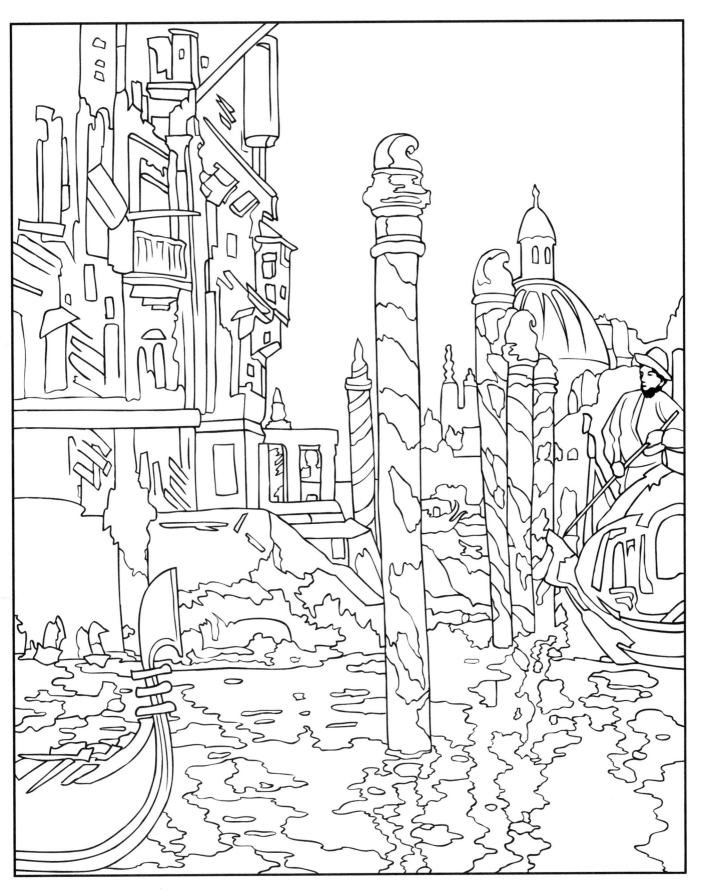

21. **The Grand Canal, Venice.** 1874. Oil on canvas. 22½ in. x 18¾ in.

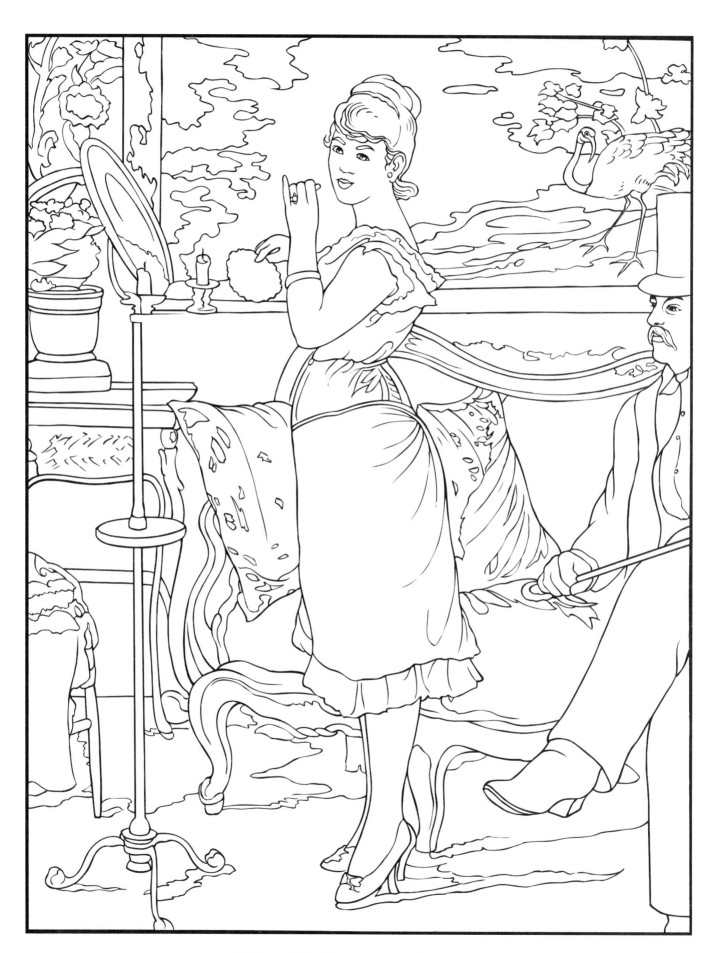

22. **Nana.** 1877. Oil on canvas. 59 in. x 45½ in.

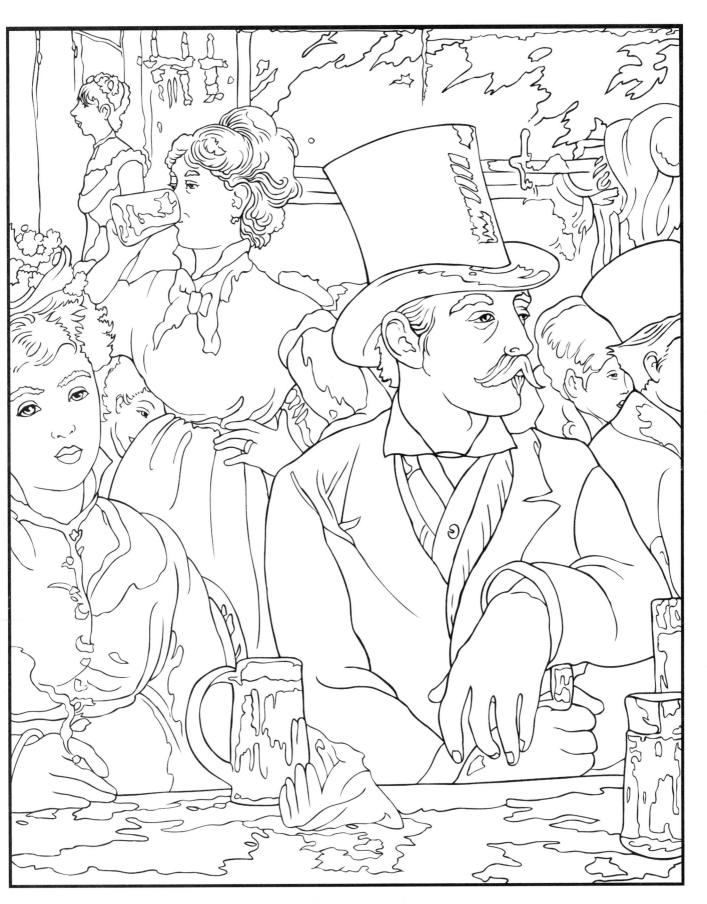

23. **Café-Concert.** 1878. Oil on canvas. 19 in. x 12¹³⁄₁₆ in.

24. **Couple at 'Père Lathuille.'** 1879. Oil on canvas. 36⅔ in. x 44 in.

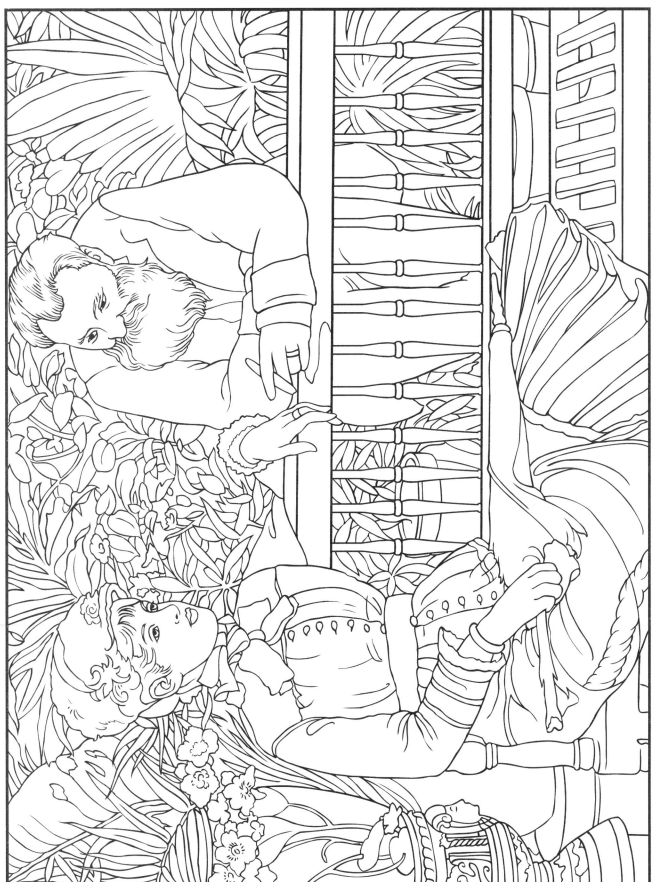

25. **In the Conservatory.** 1879. Oil on canvas. 46 in. x 60 in.

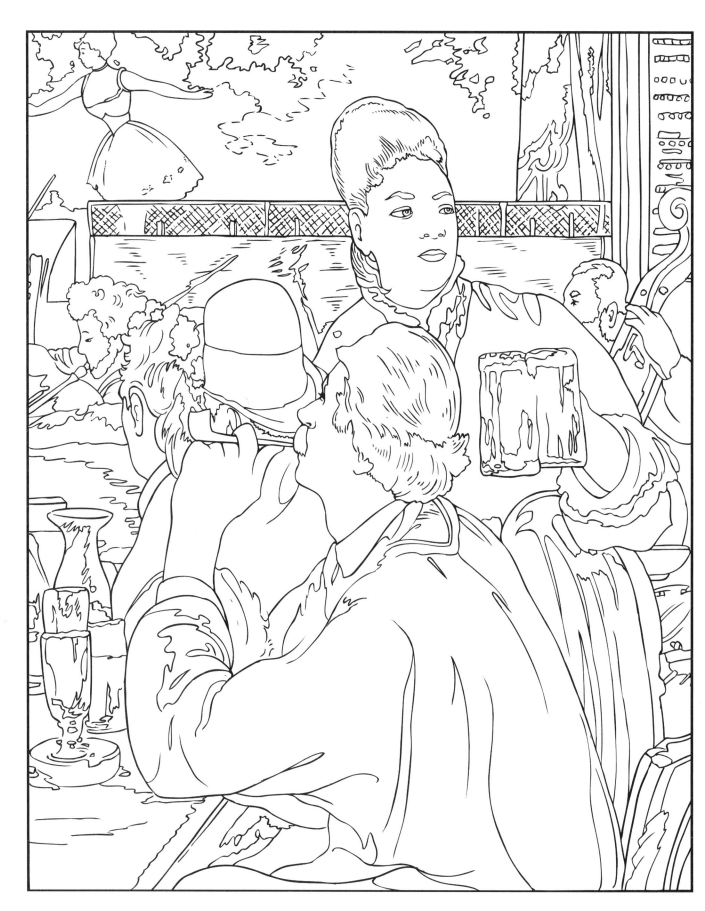

26. **Corner in a Café-Concert.** 1878–79. Oil on canvas. 38¼ in. x 30½ in.

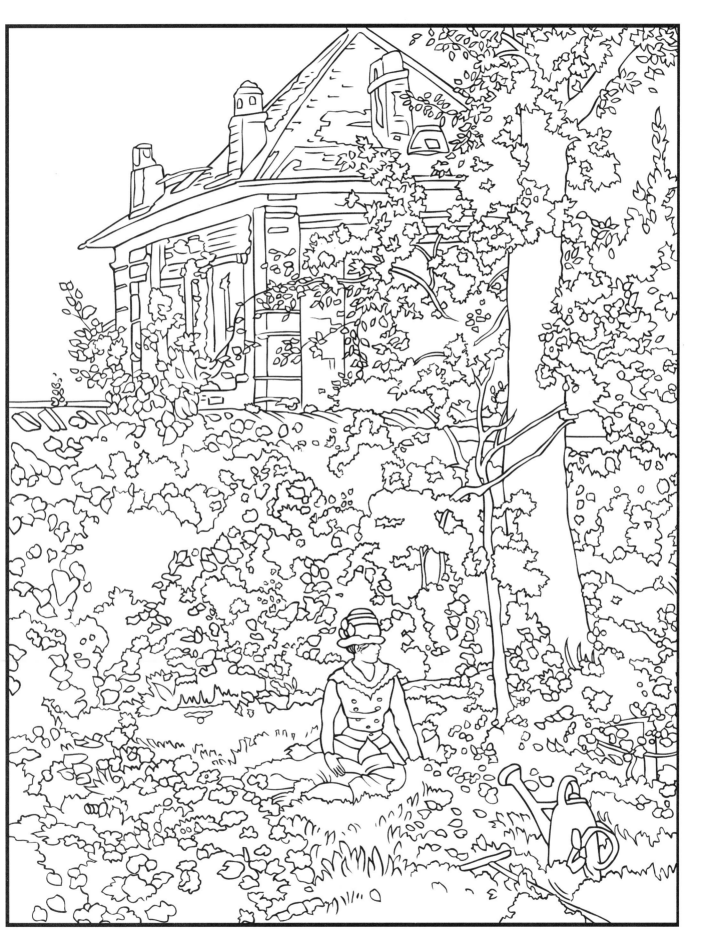

27. **Mlle. Marguerite in the Garden at Bellevue.** 1880. Oil on canvas. 36¼ in. x 27½ in.

28. **A Bar at the Folies-Bergère.** 1881. Oil on canvas. 37½ in. x 51 in.

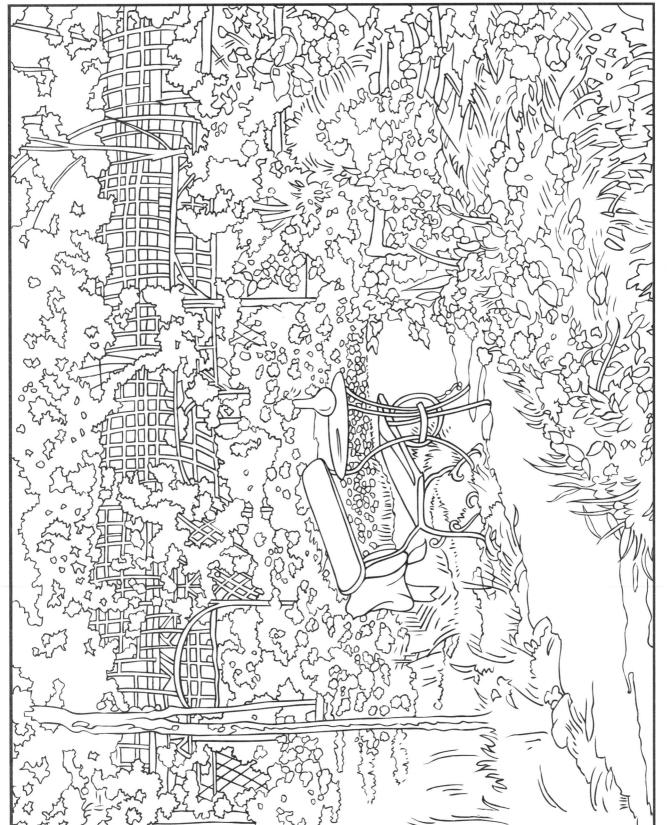

29. **The Bench.** 1881. Oil on canvas. 26 in. x 32½ in.

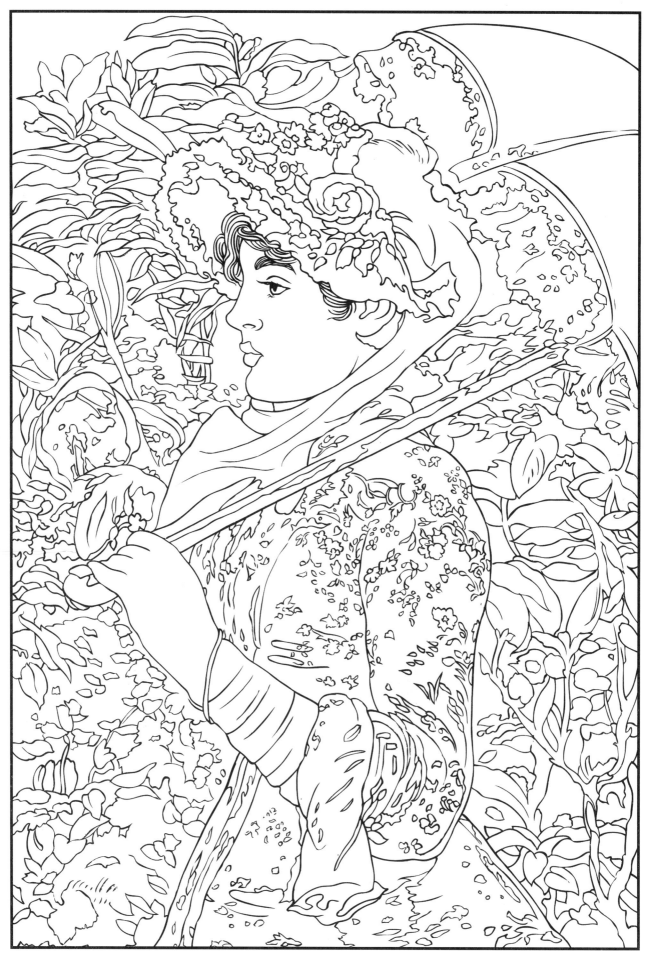

30. **Jeanne: Spring.** 1881. Oil on canvas. 29³⁄₁₆ in. x 24 in.